Copyright © 2019 by Hannah Rosales-Alfaro
All rights reserved.

This book or parts thereof may not be reproduced in any form, stored in any retrieval system, or transmitted in any form by any means—electronic, mechanical, photocopy, recording, or otherwise—without prior written permission of the publisher, except as provided by United States of America copyright law. For permission requests, write to the publisher, at "Attention: Permissions Coordinator," at the web address below.

Printed in the United States of America

9 7 8 1 6 9 7 5 5 4 4 3 4

Cover and book design by Hannah Rosales- Alfaro

Published by Hannah Rosales-Alfaro

First printing October 2019

www.rosalesalfaro.wixsite.com/books

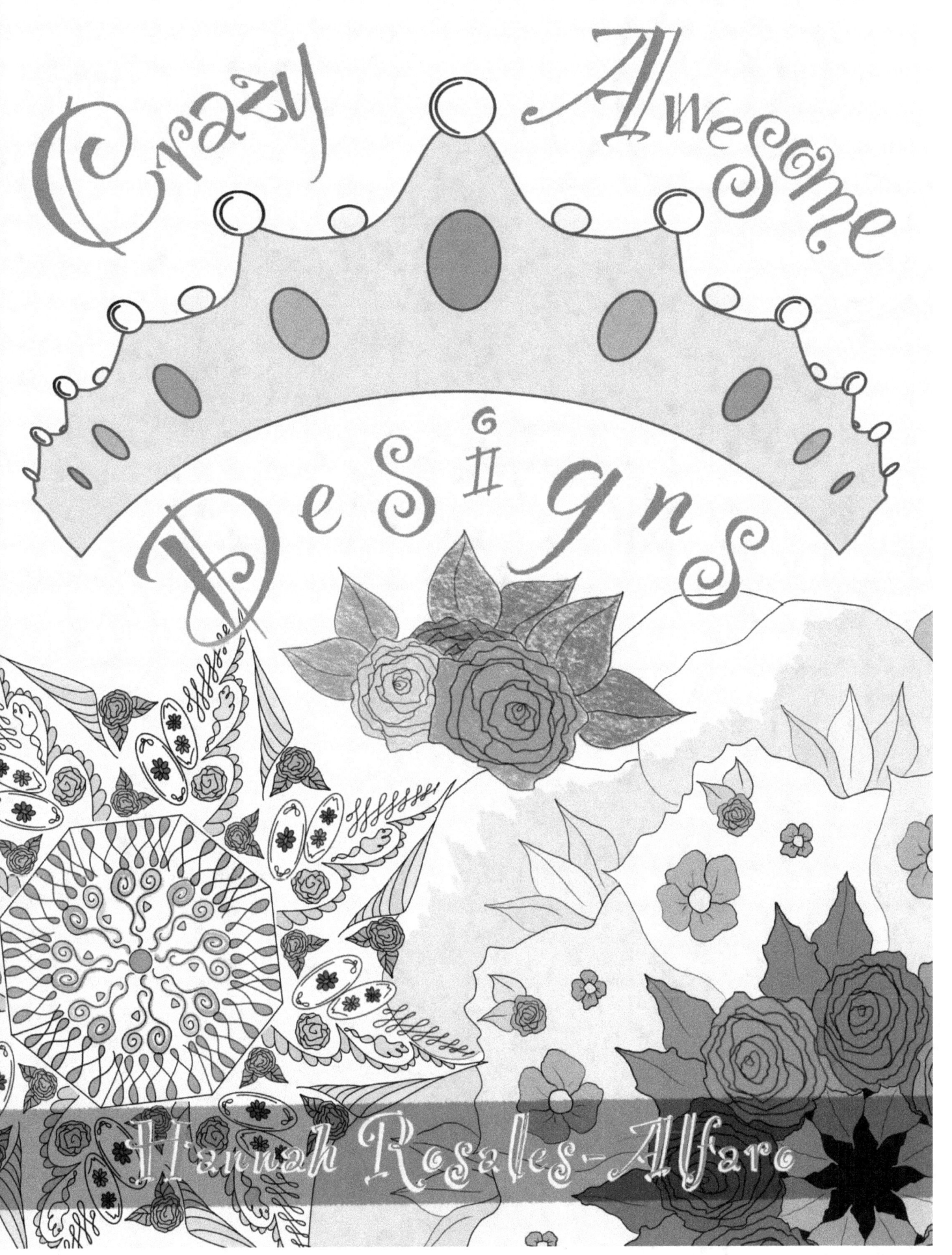

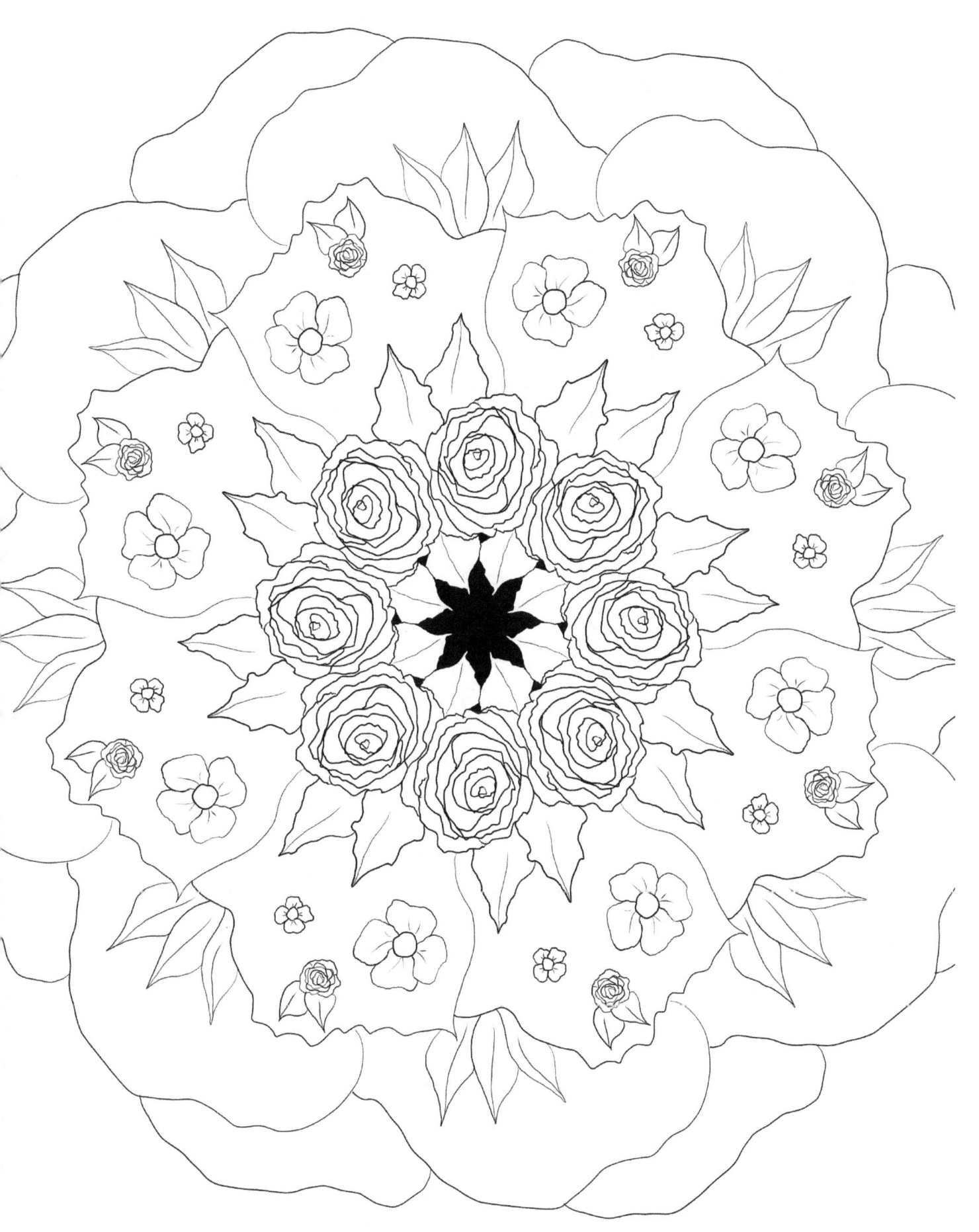

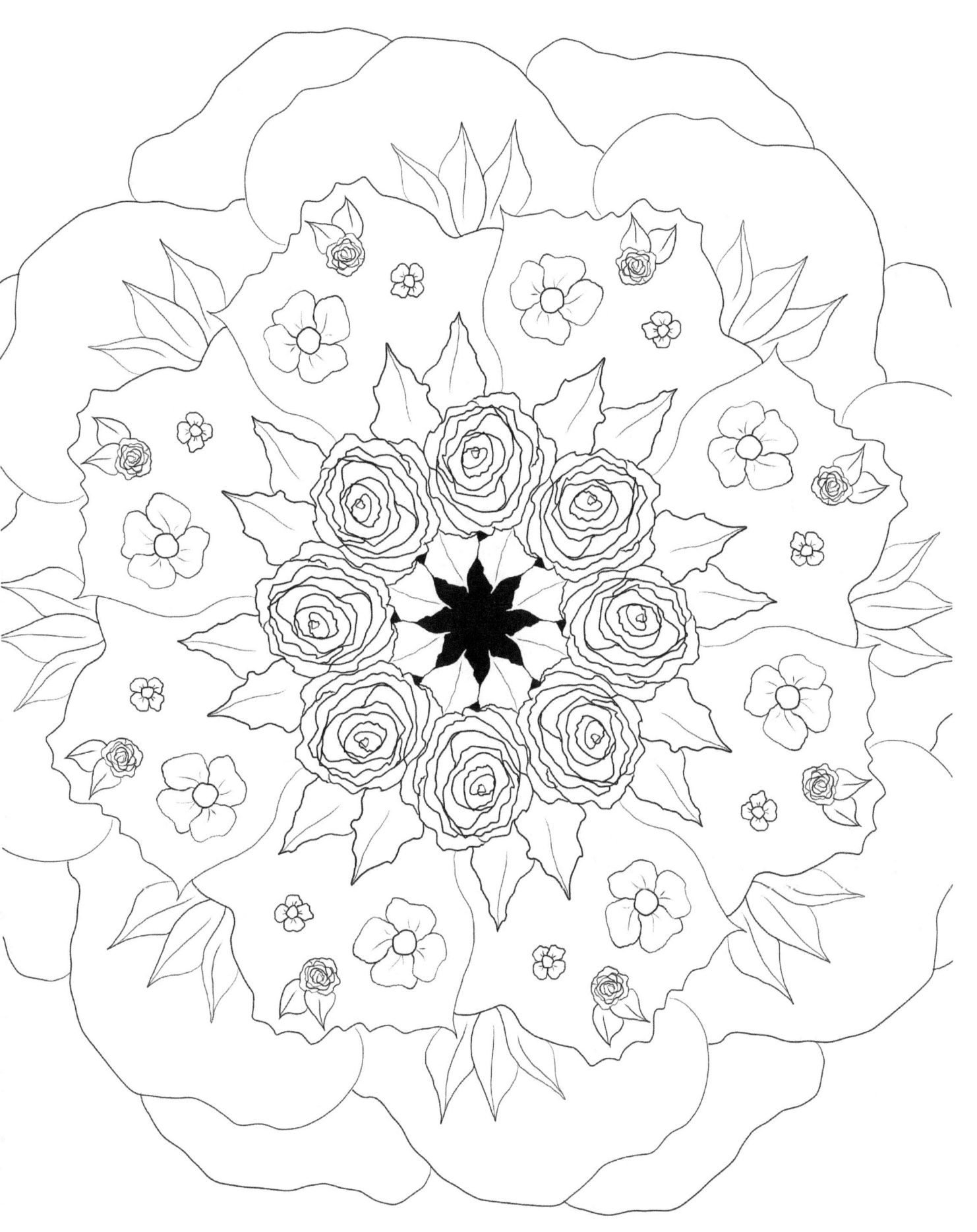

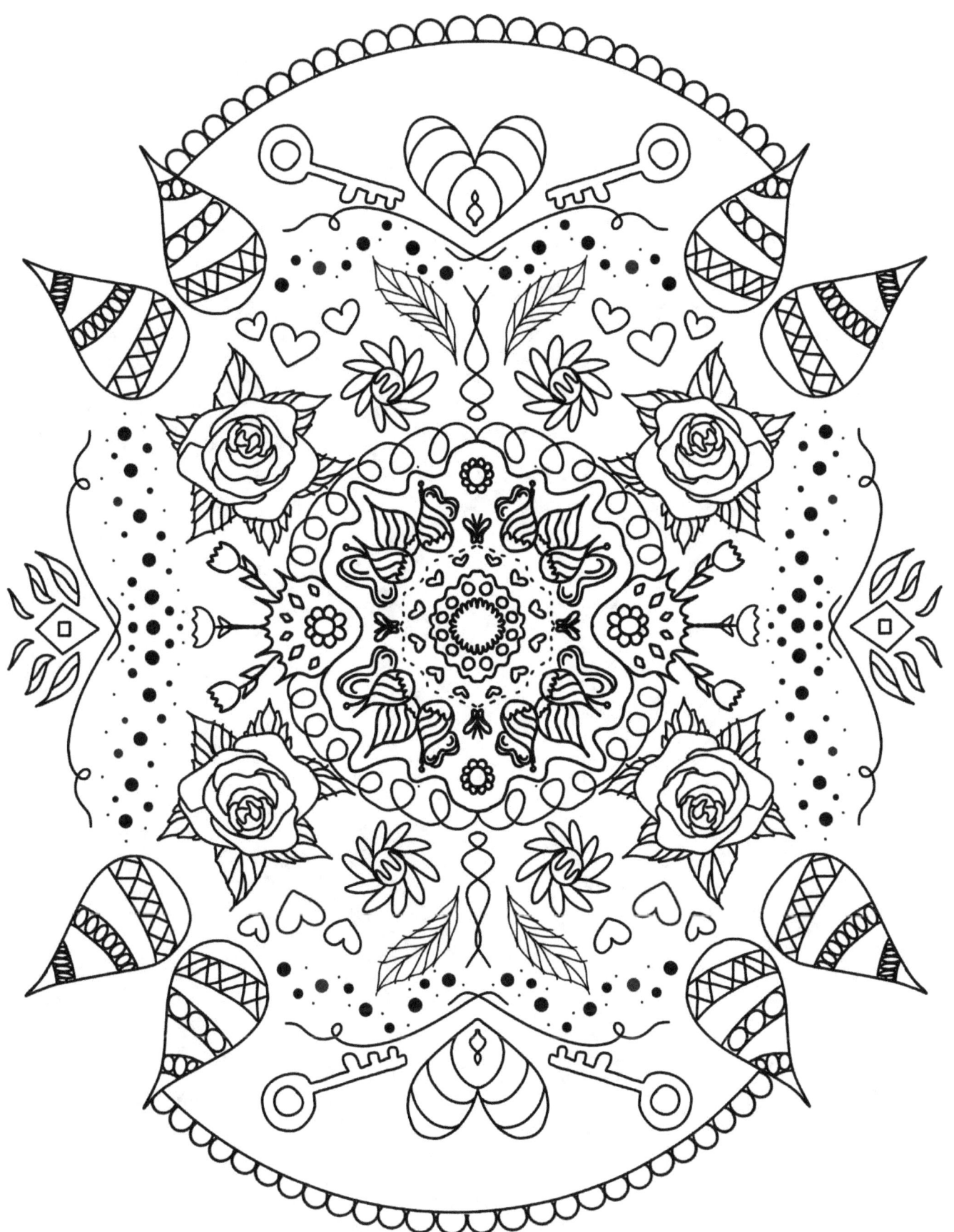

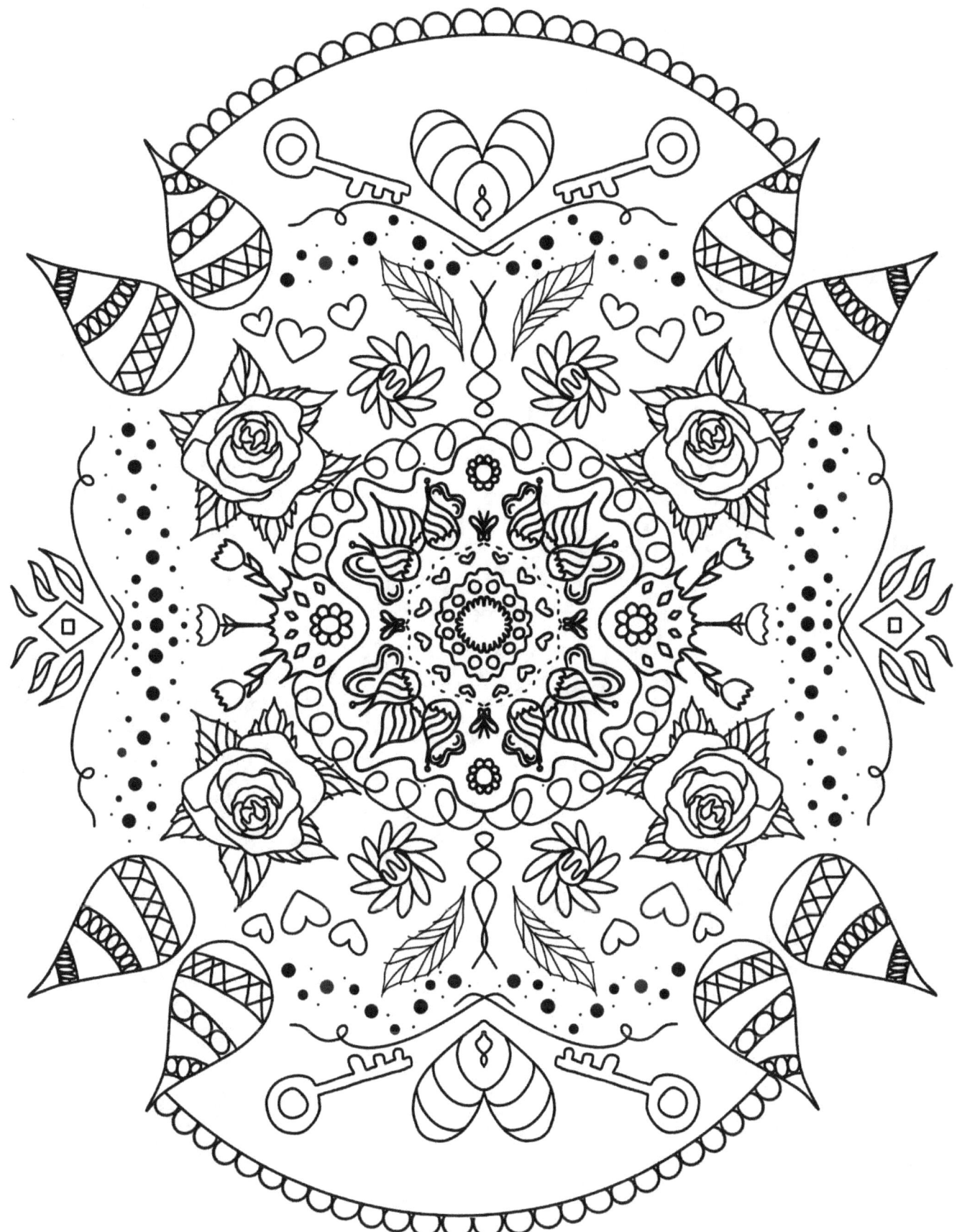

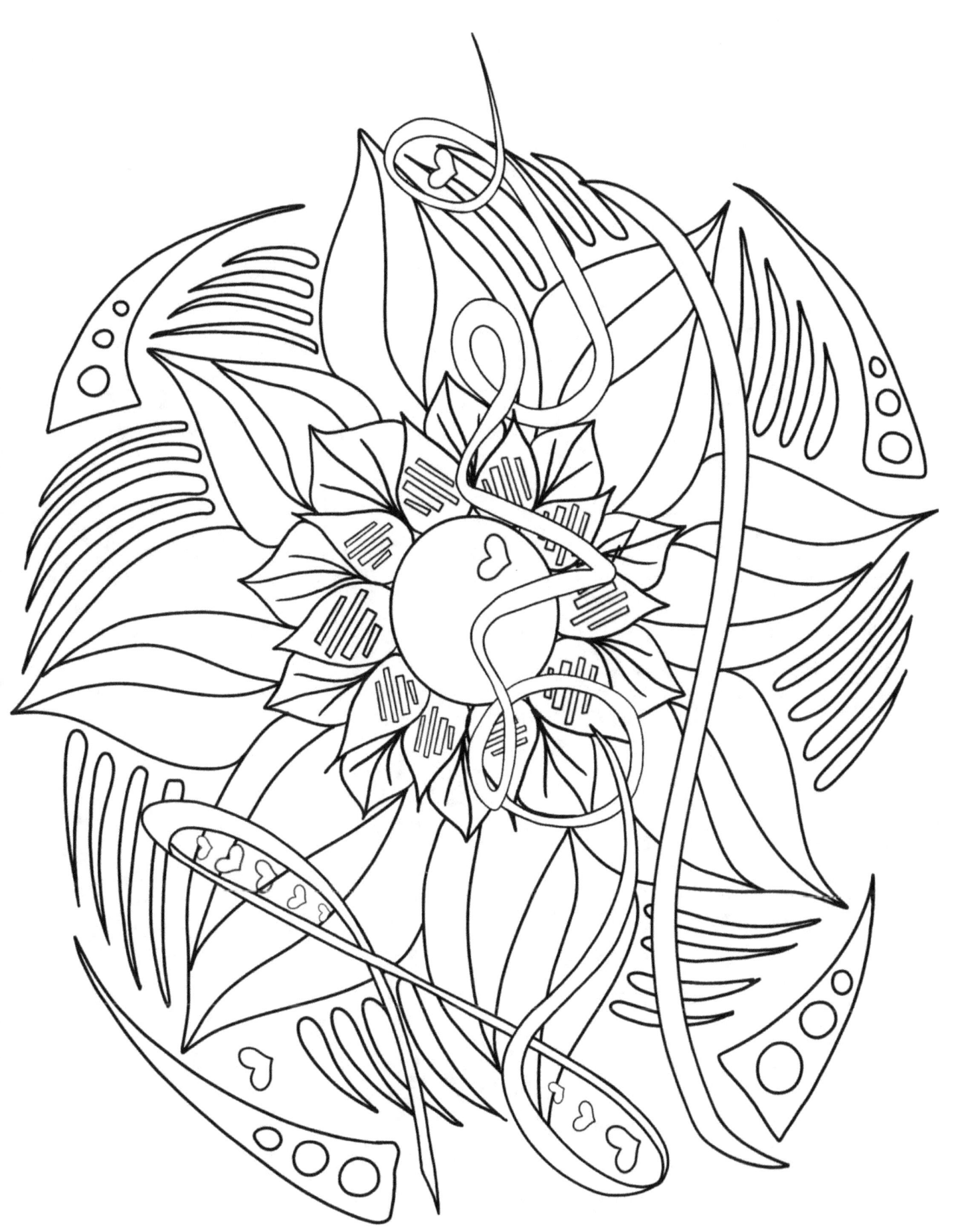

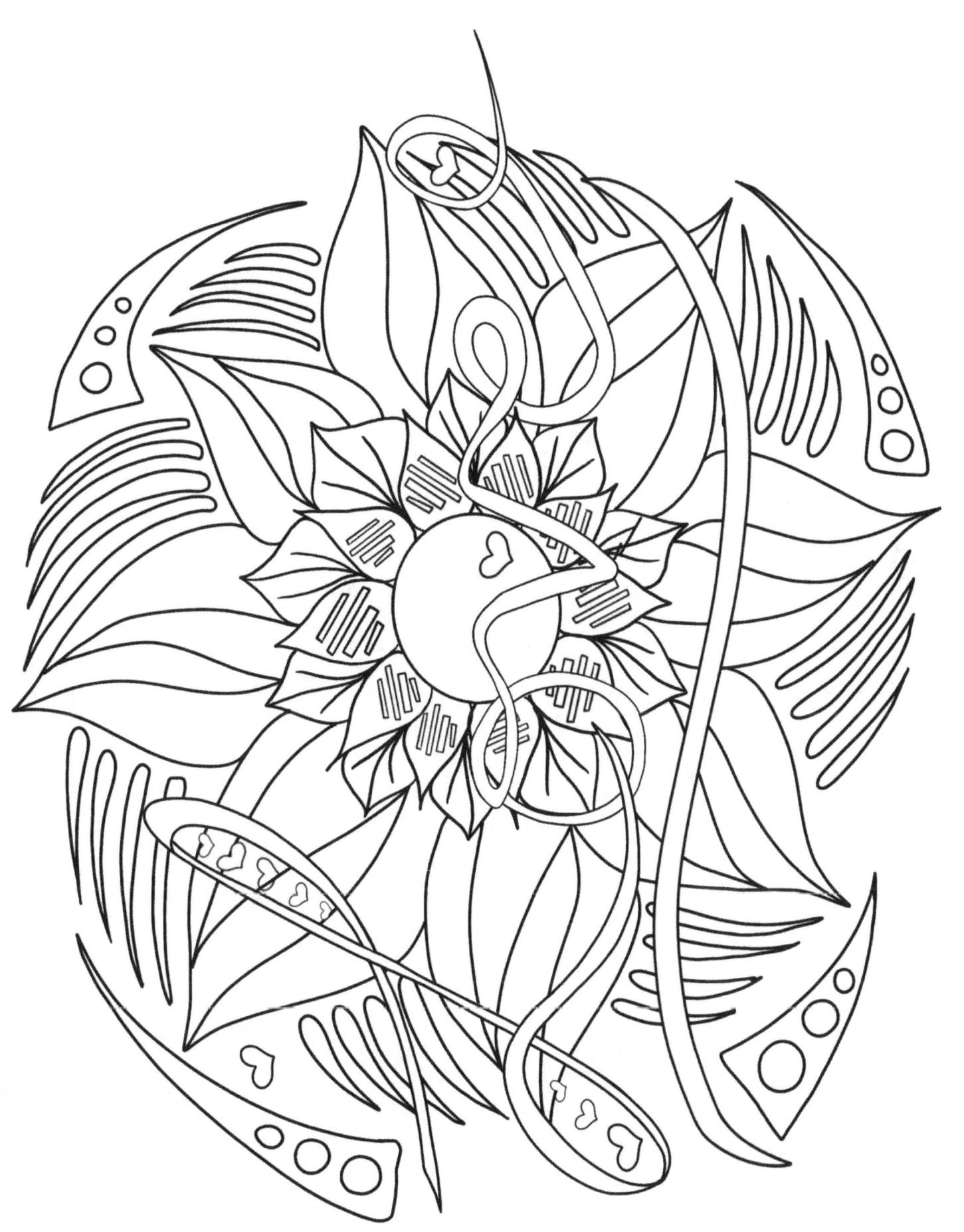

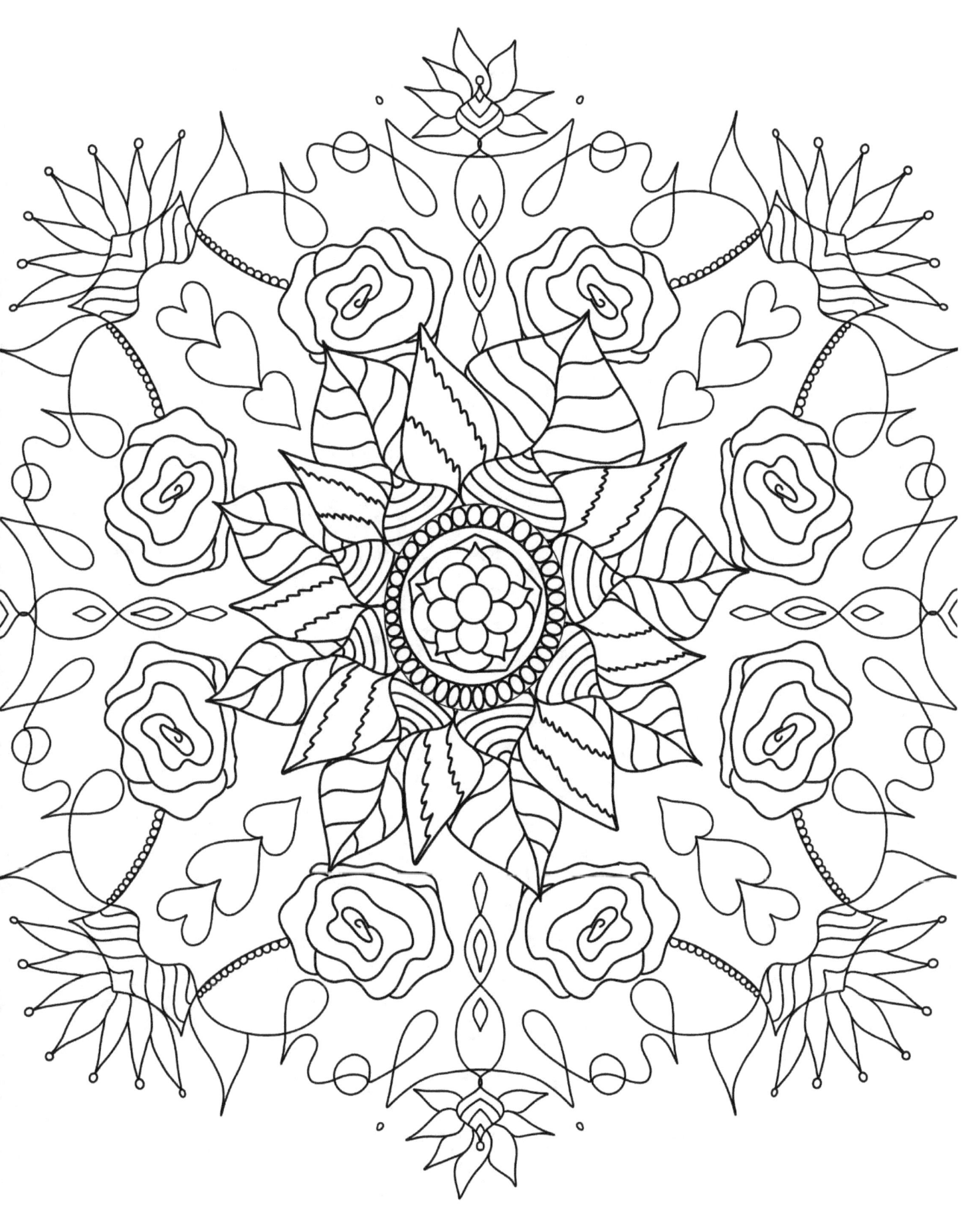

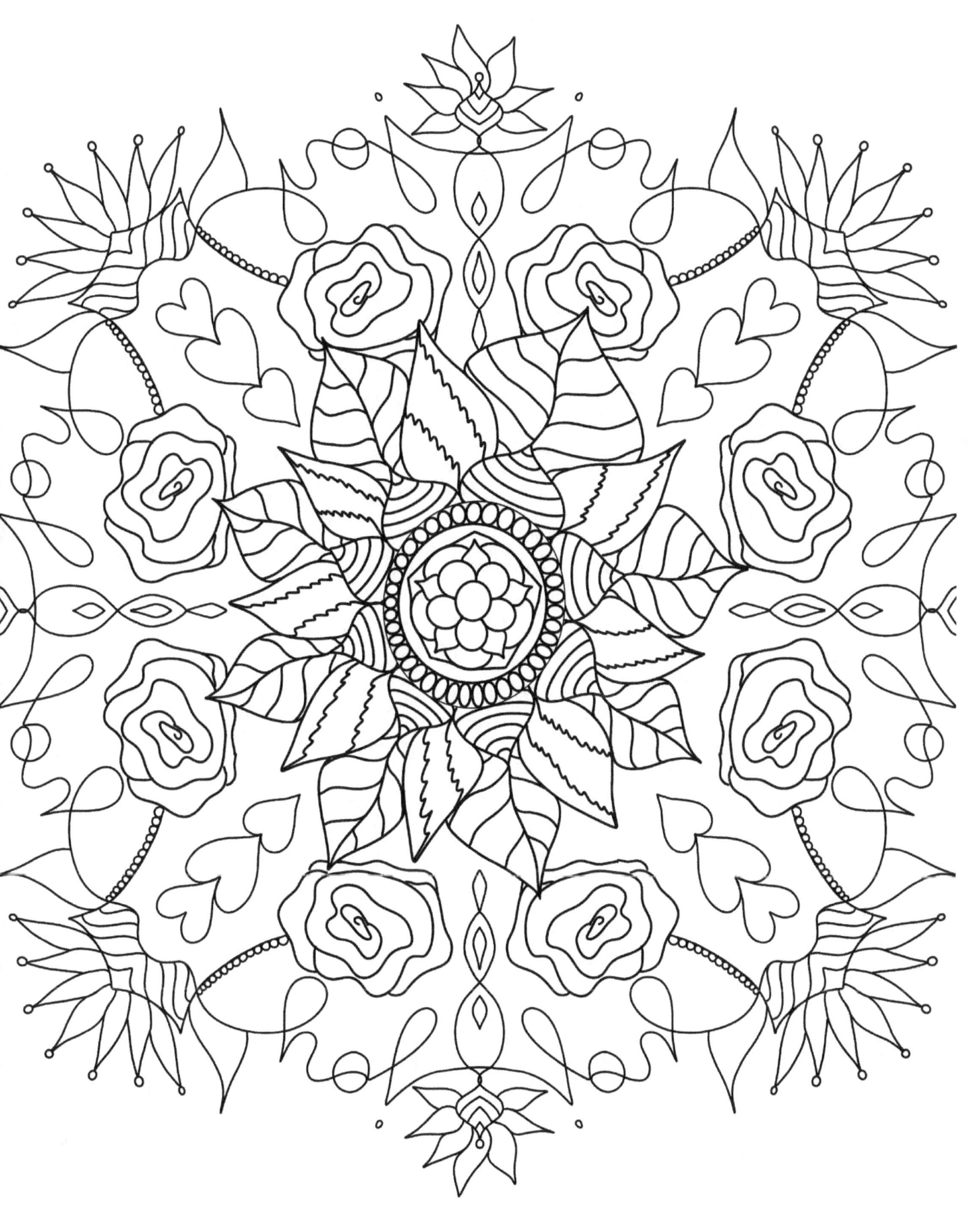

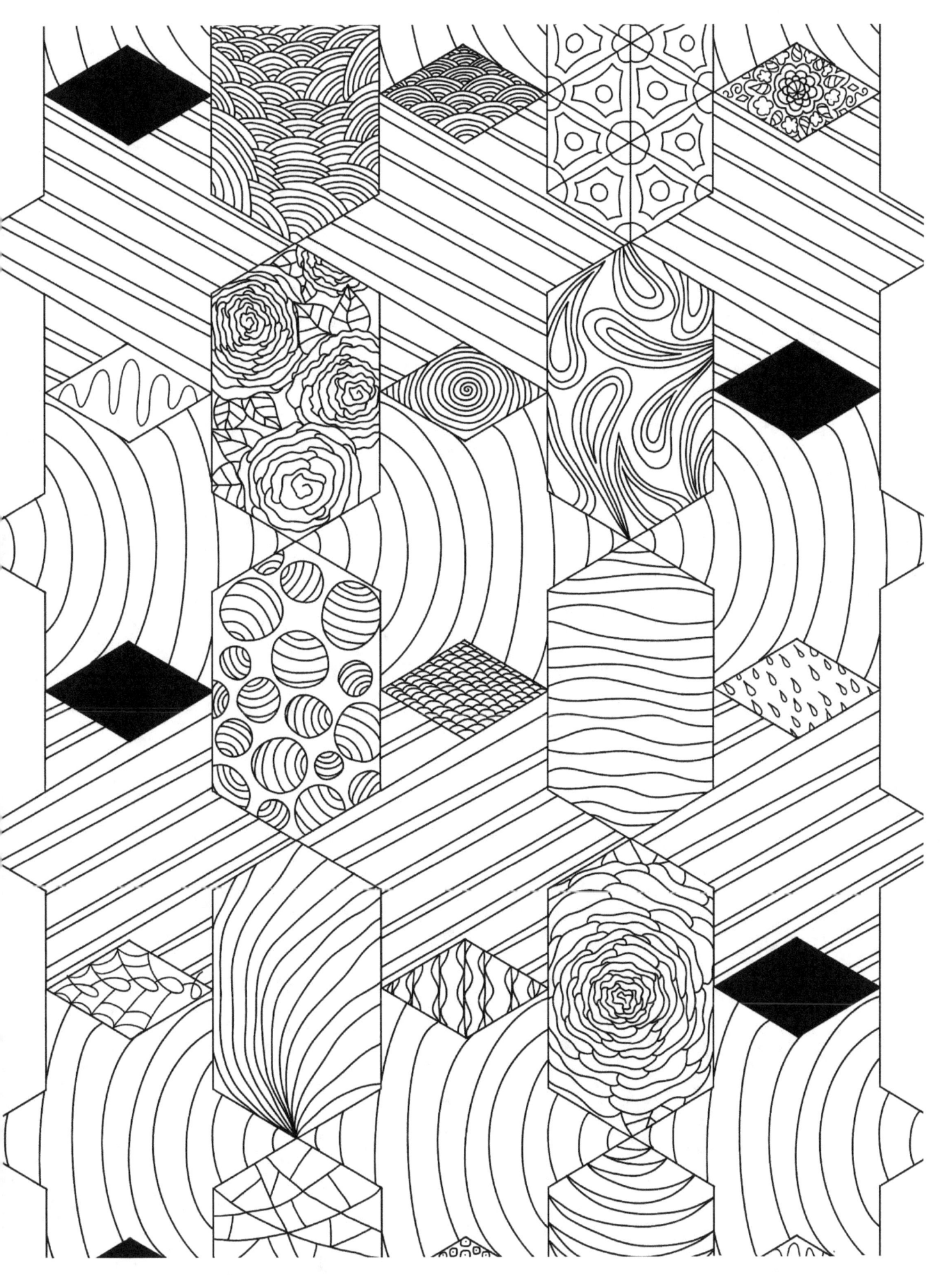

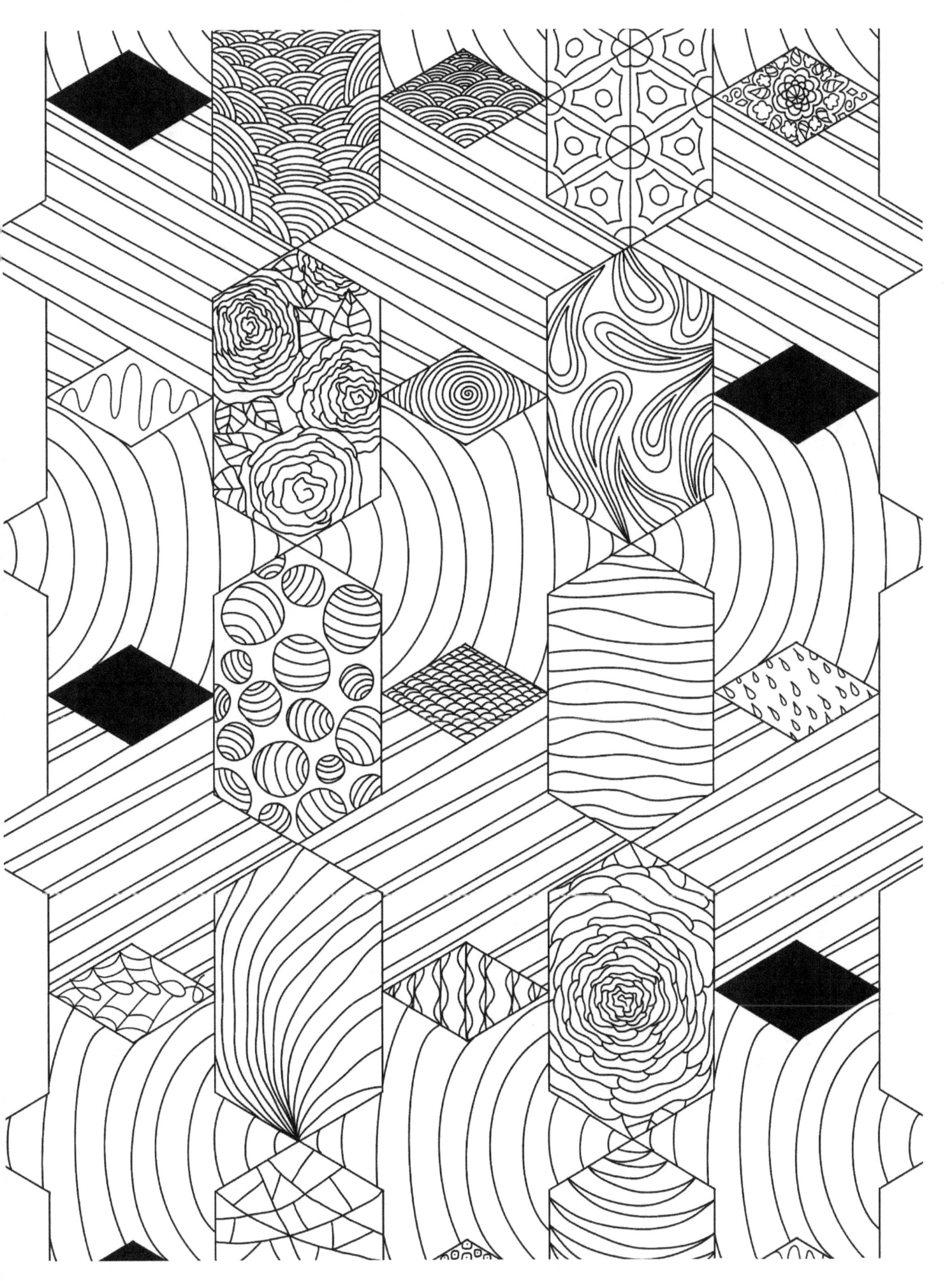

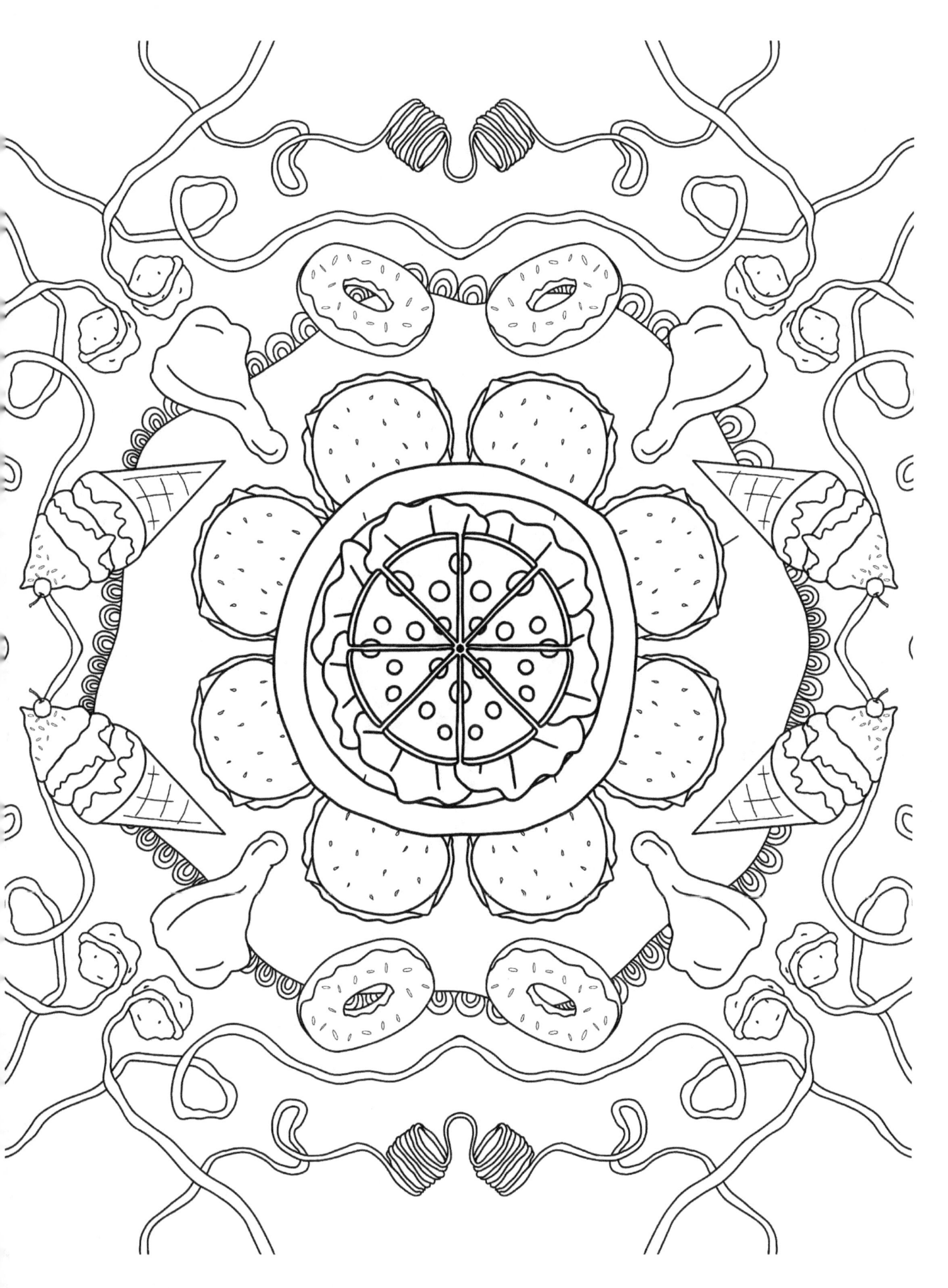

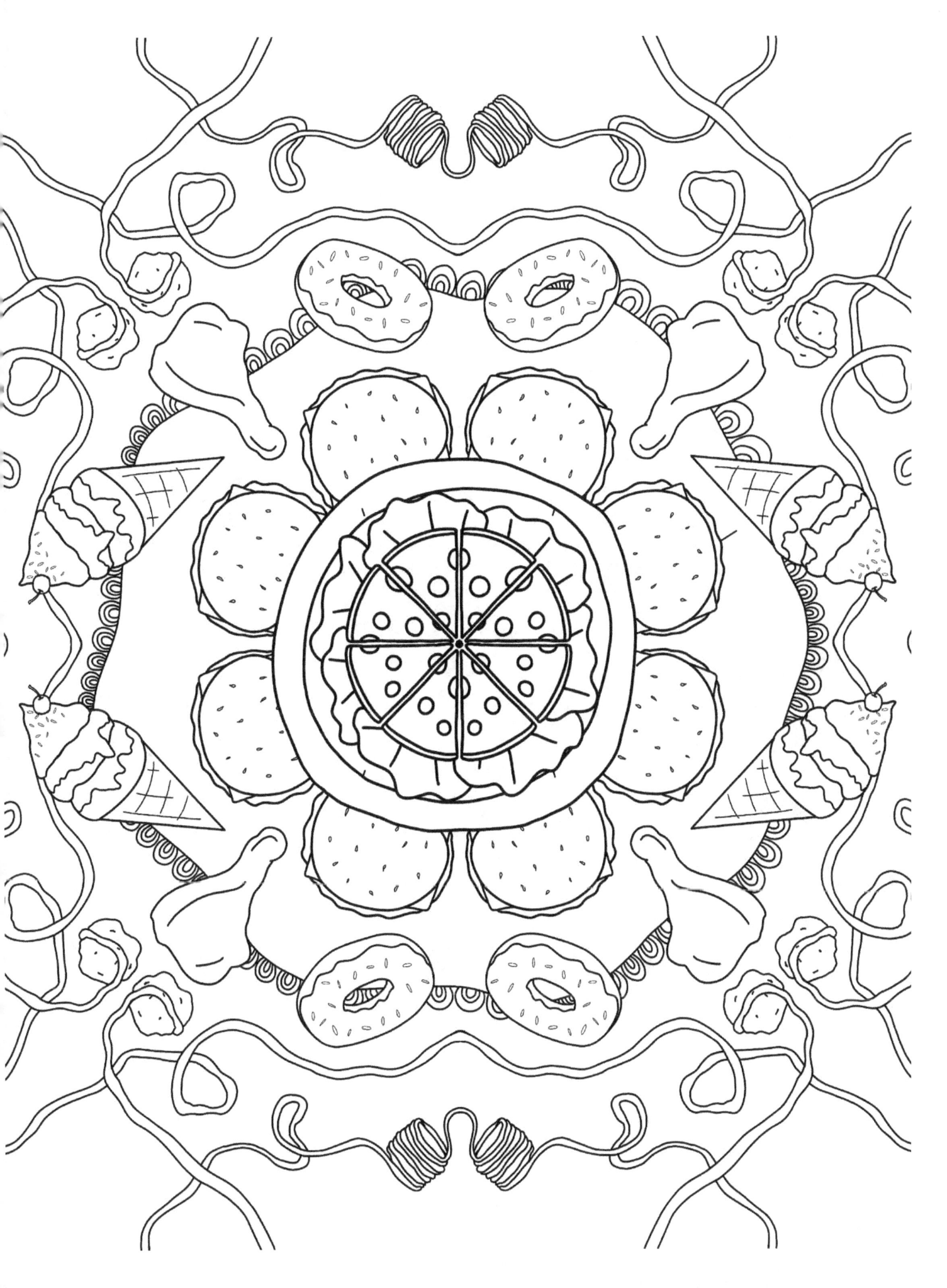

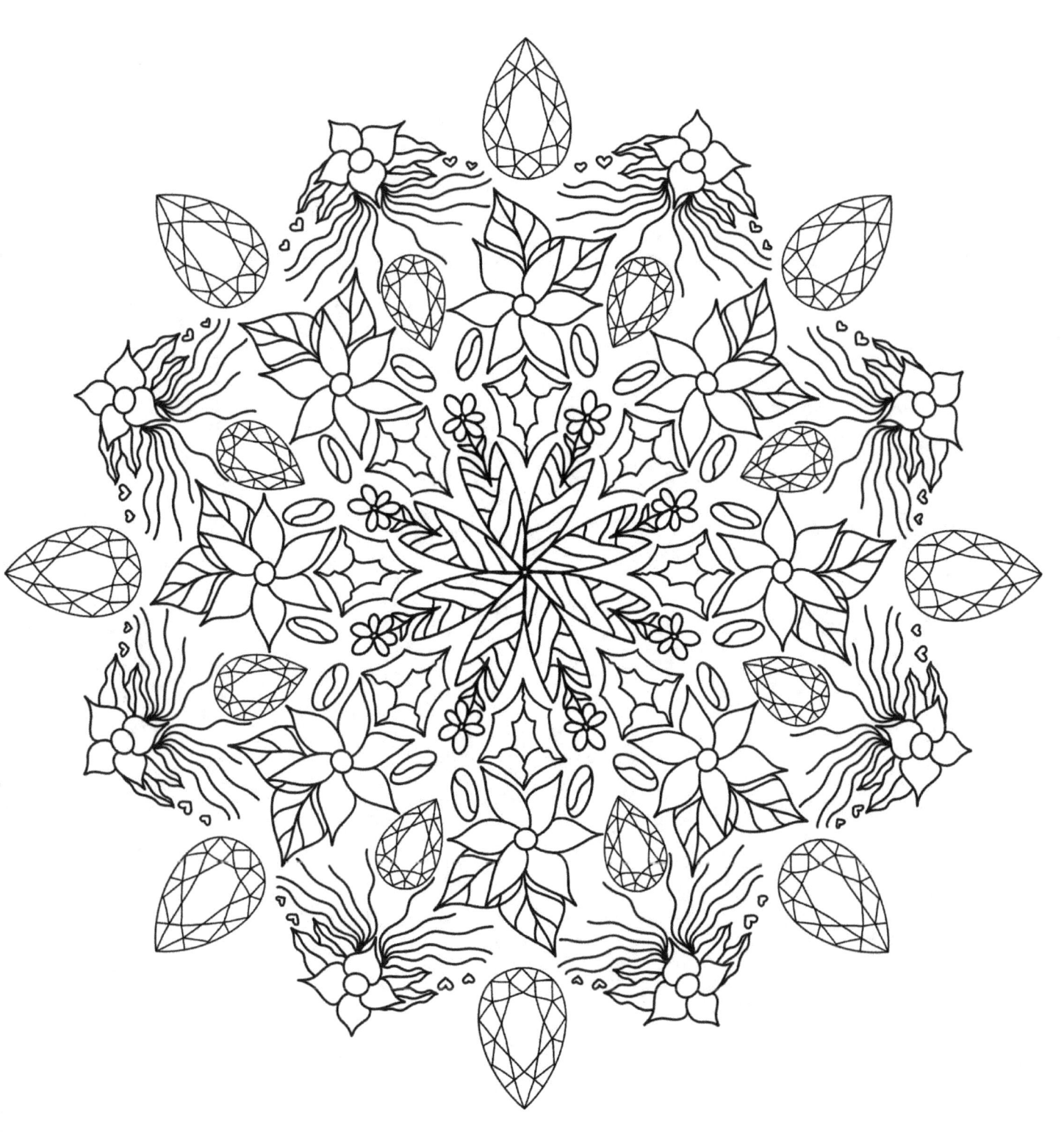

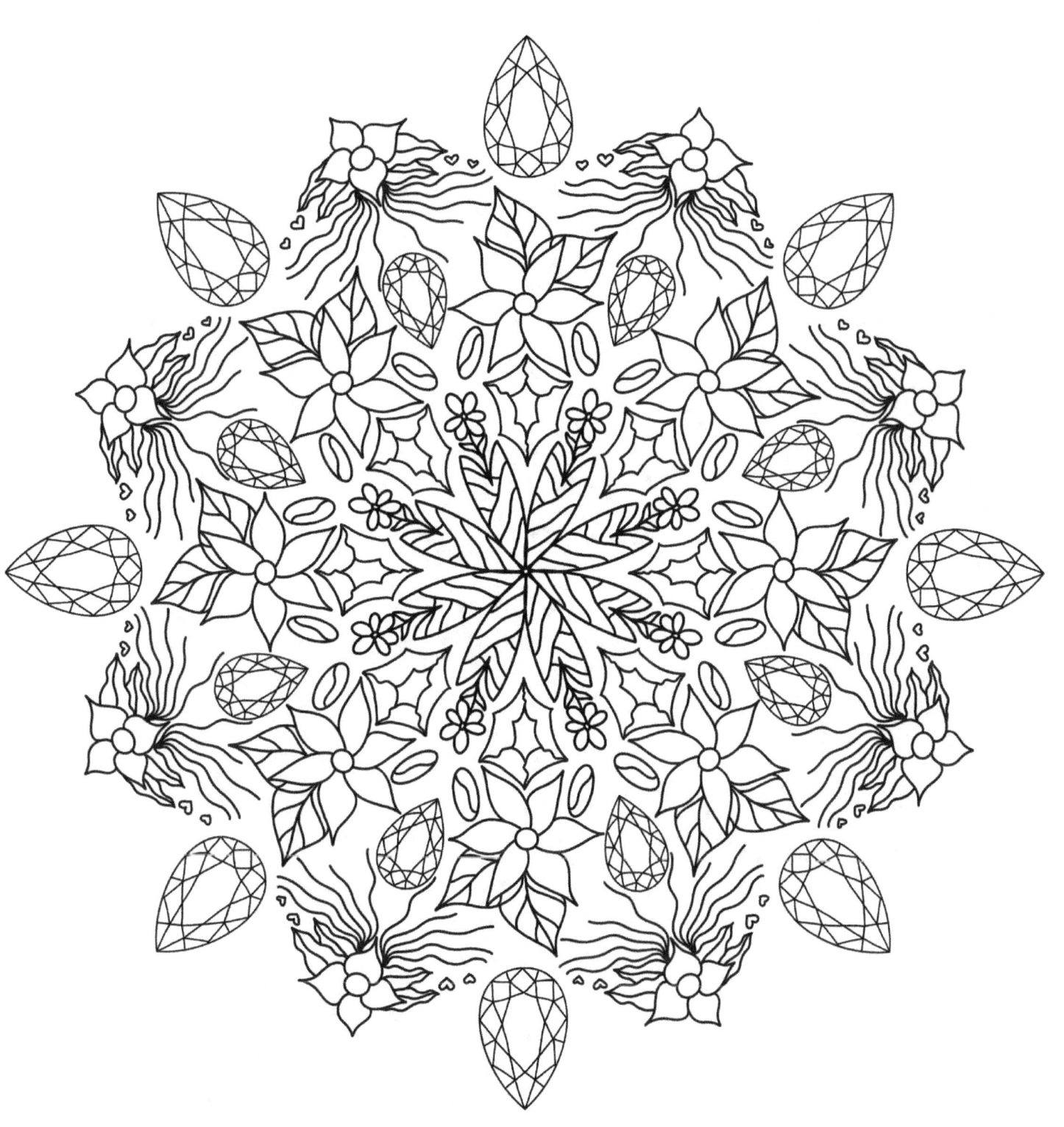

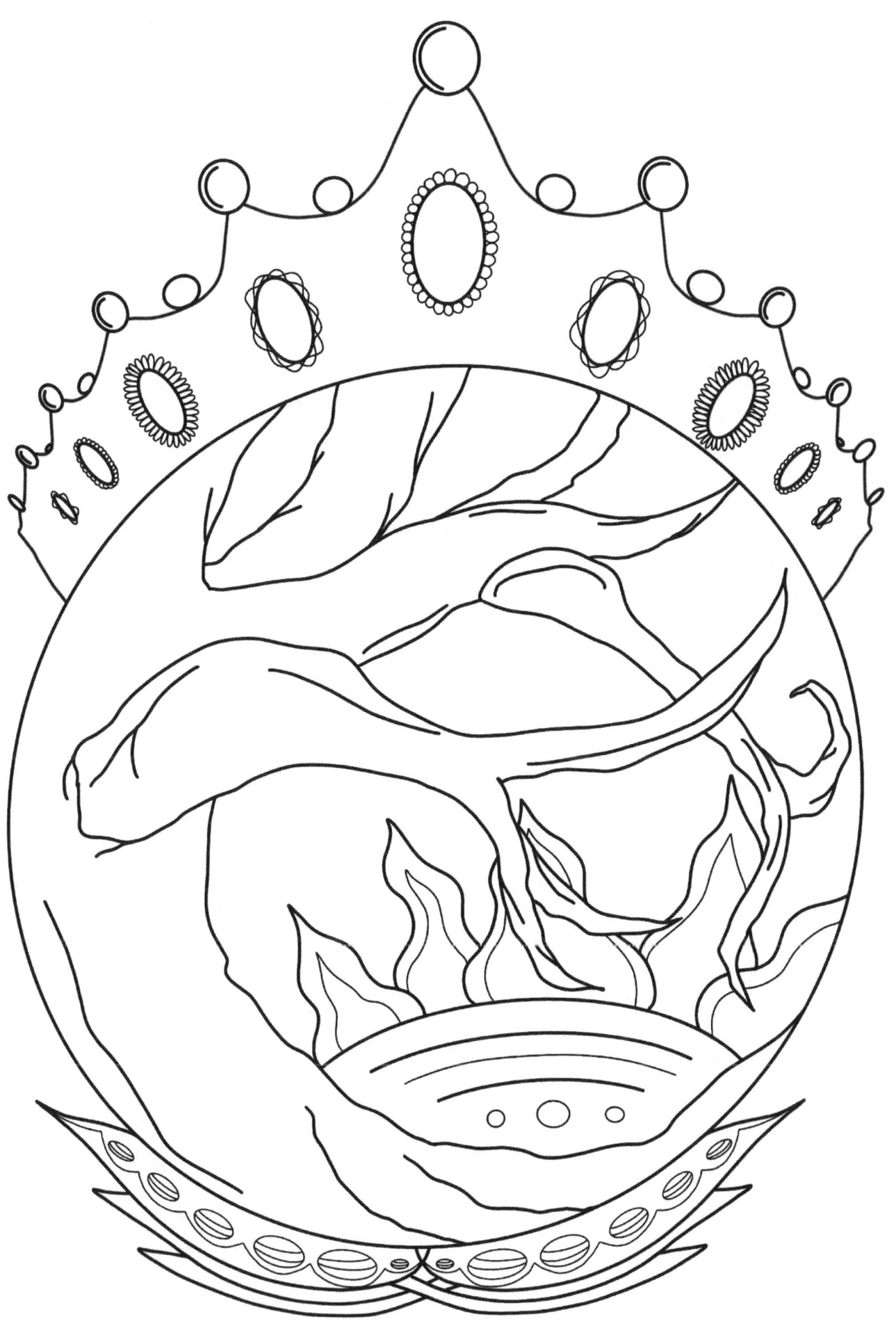

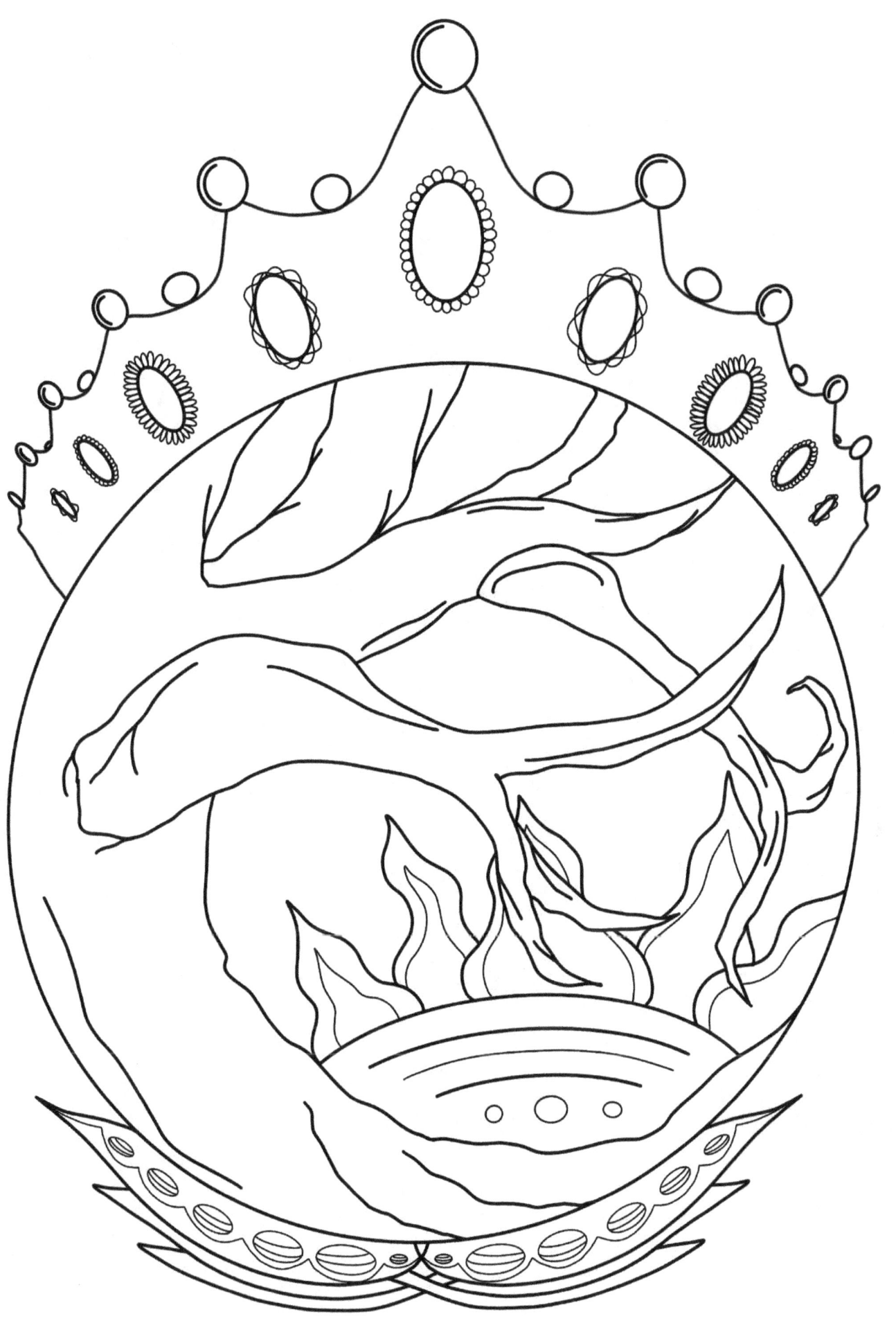

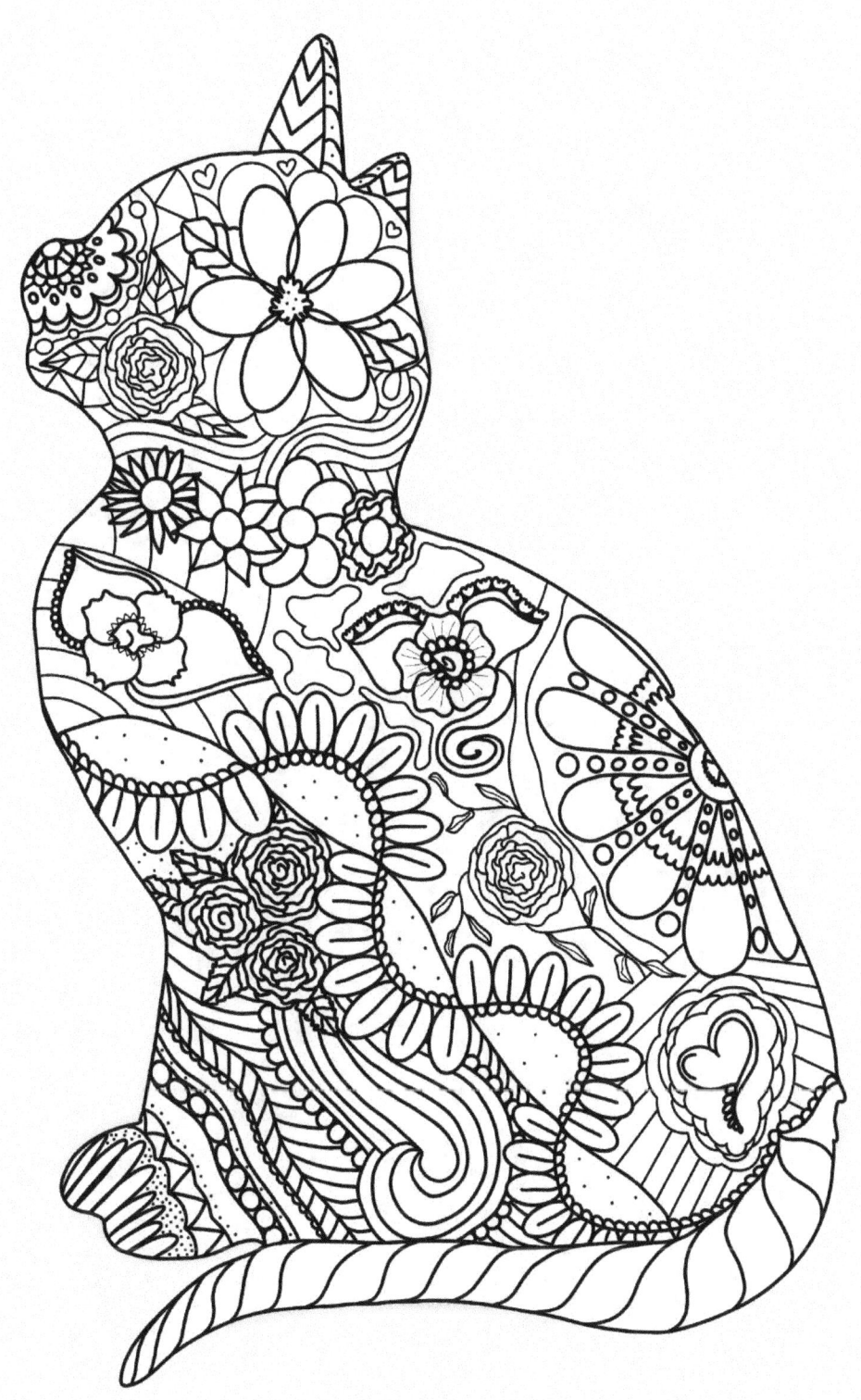

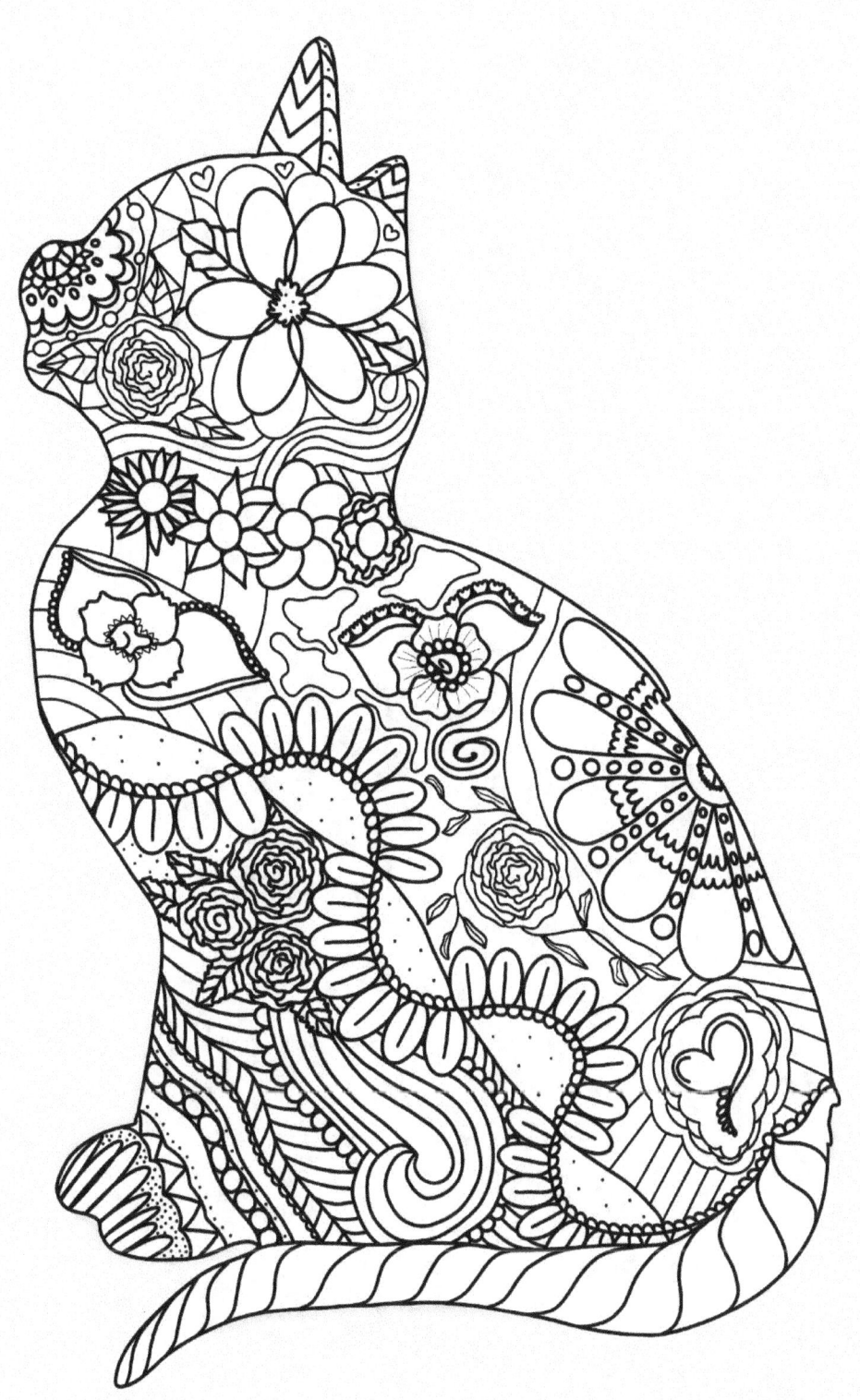

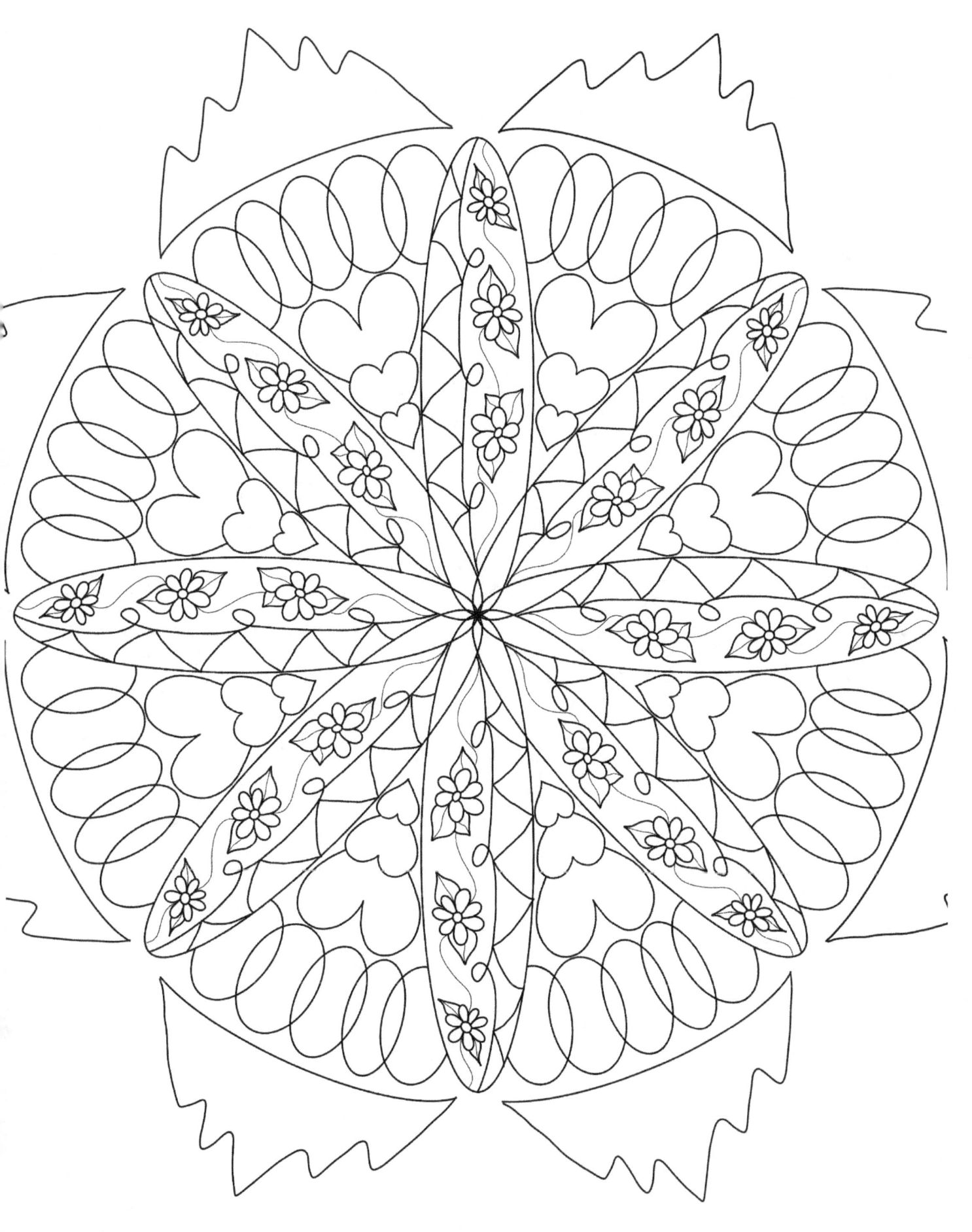

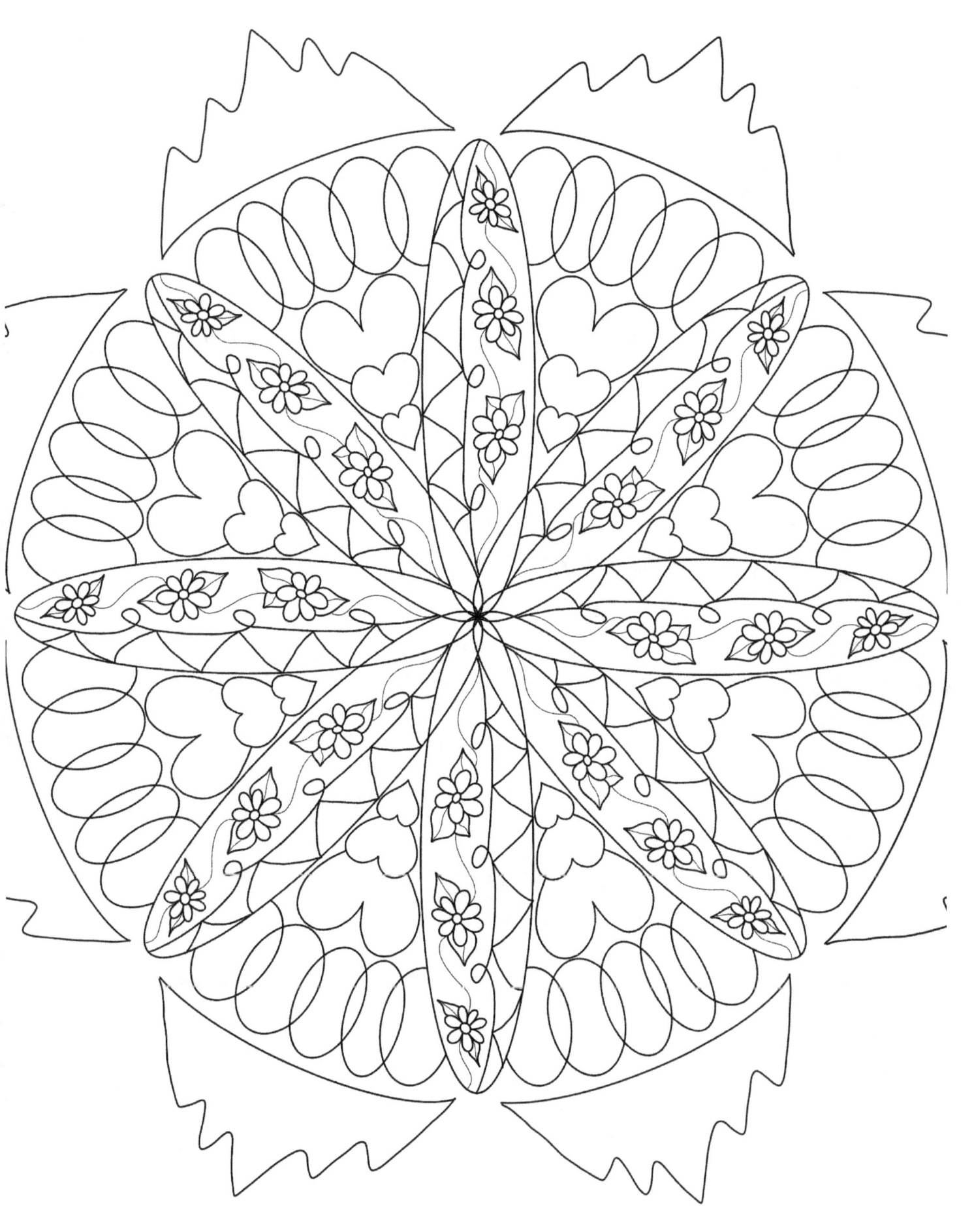

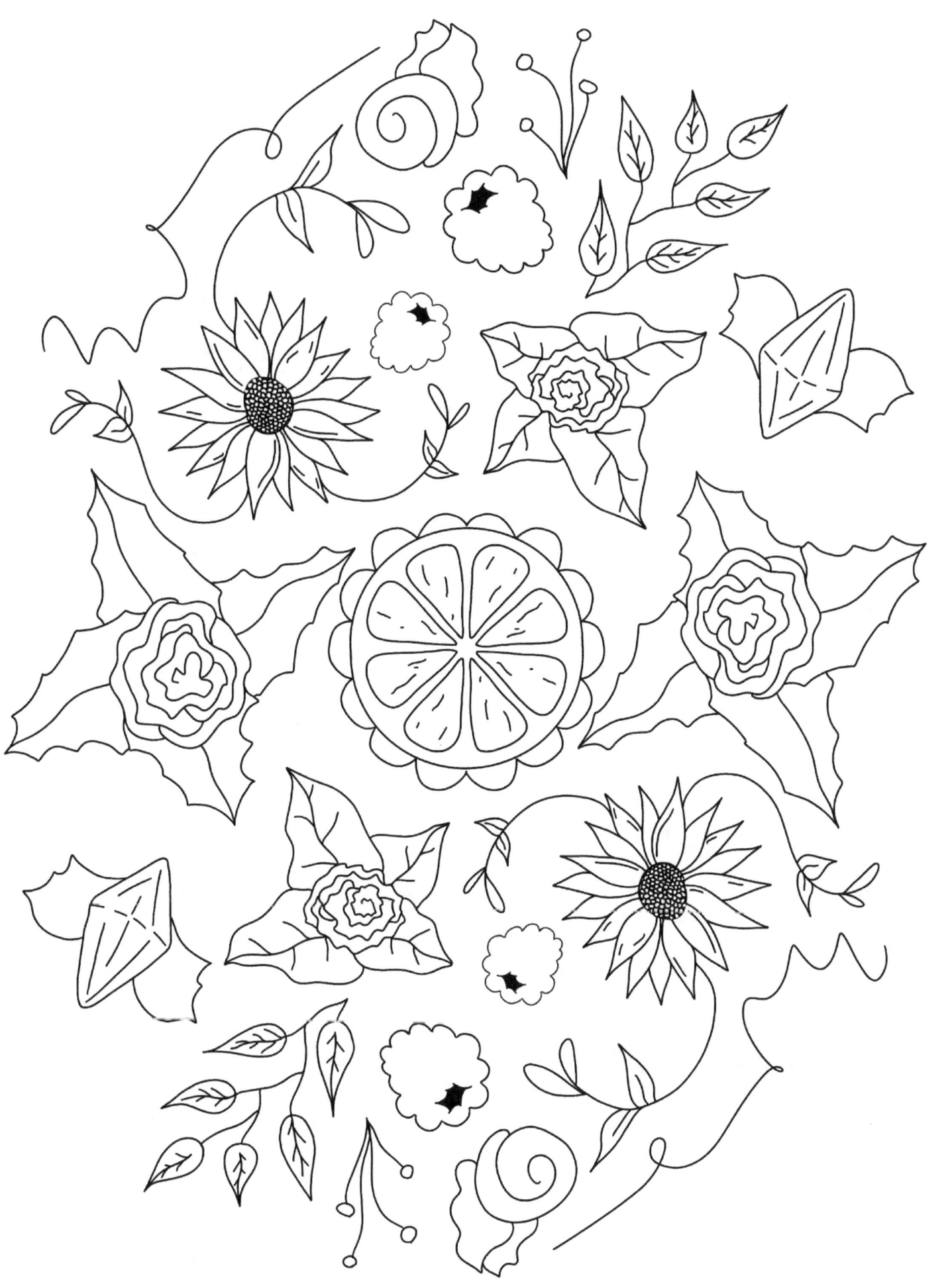

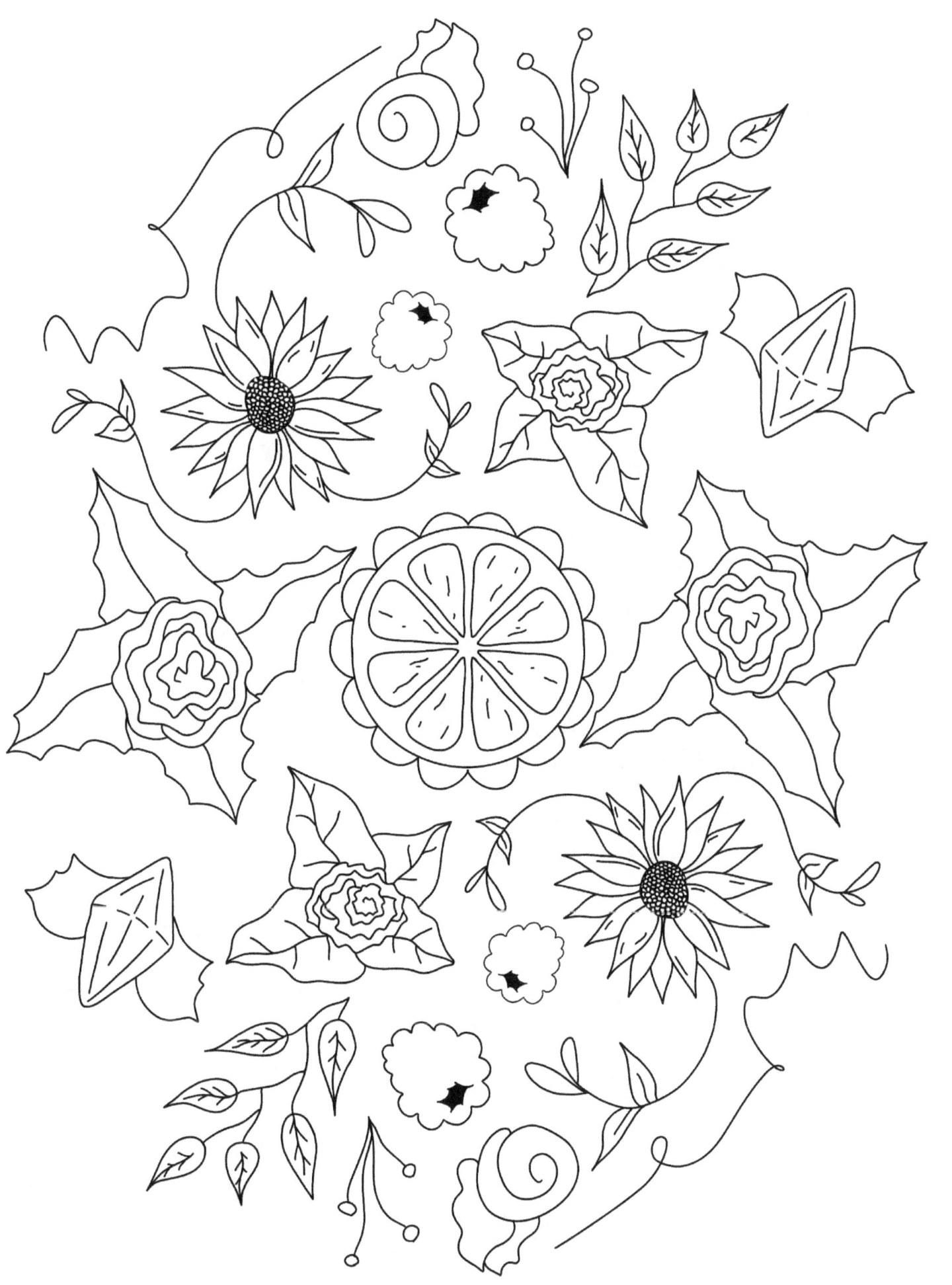

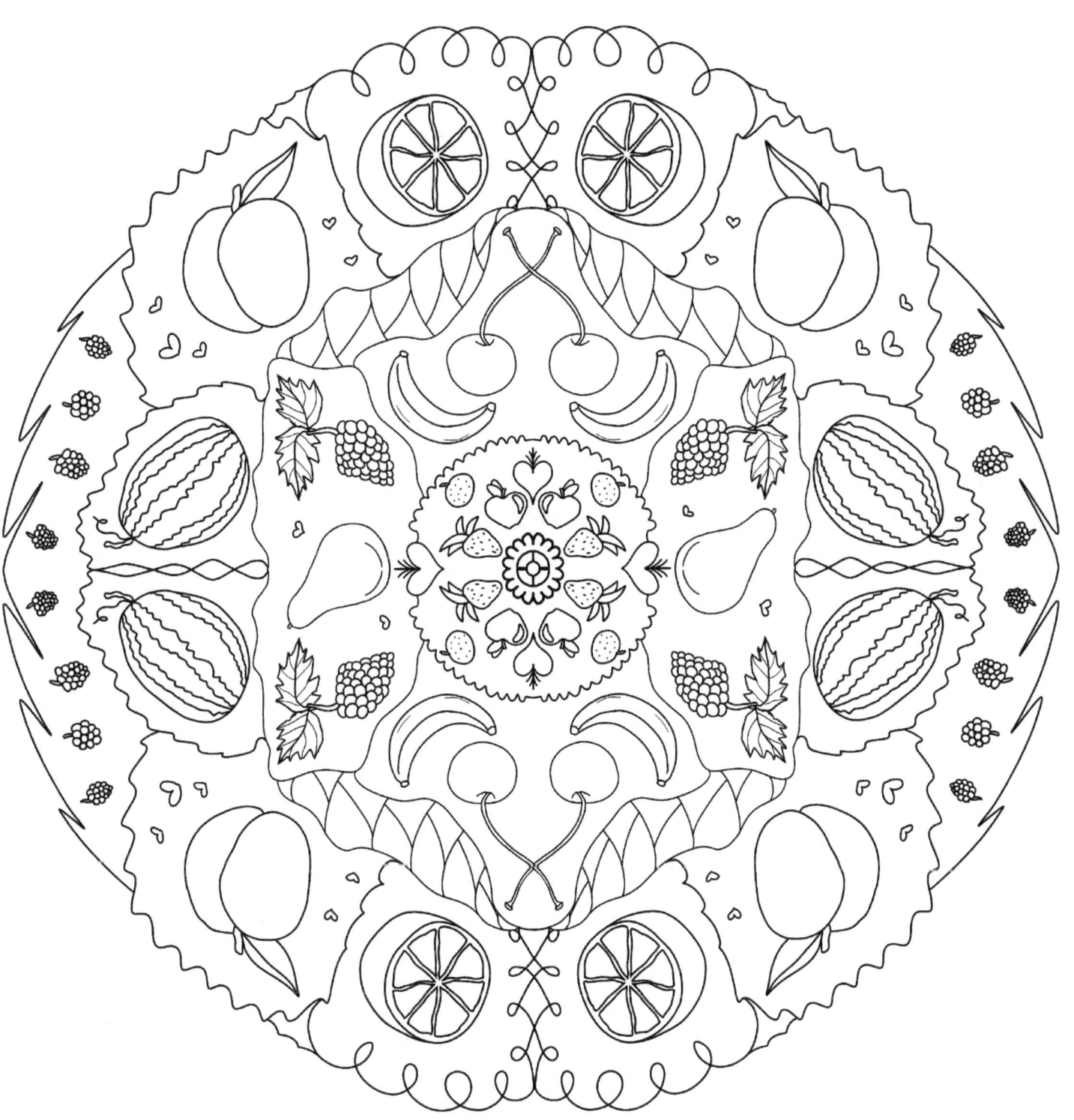

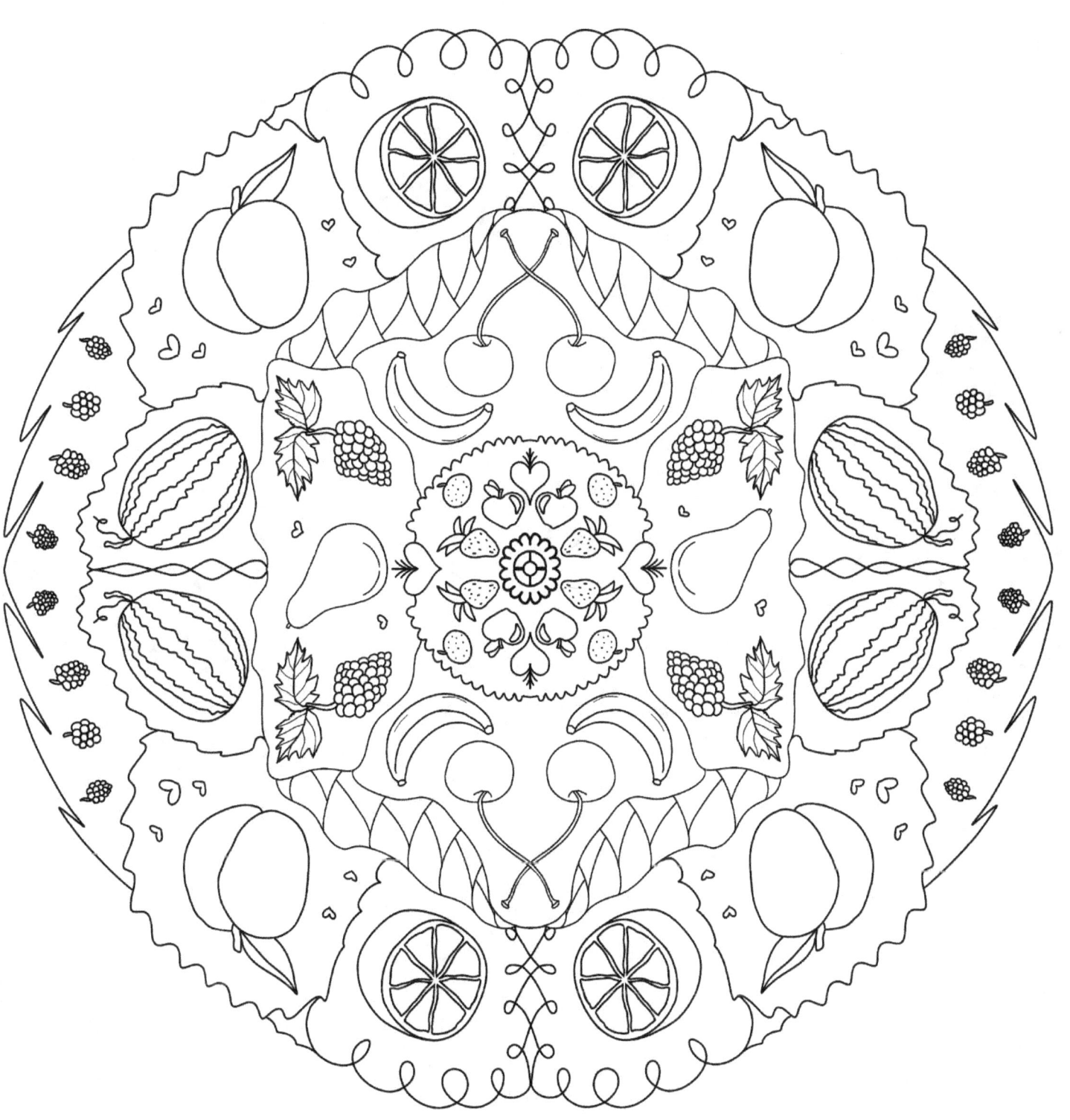

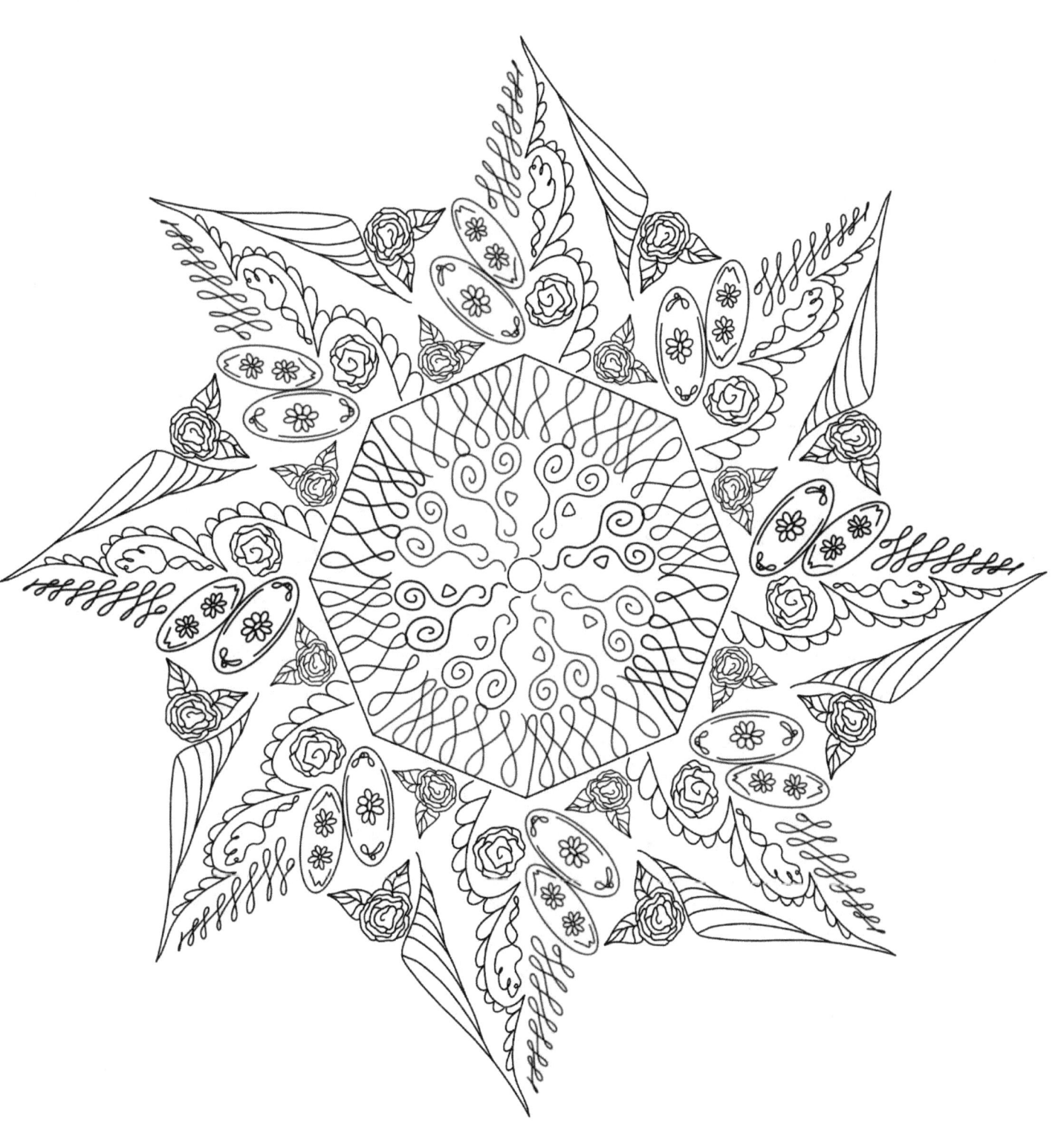

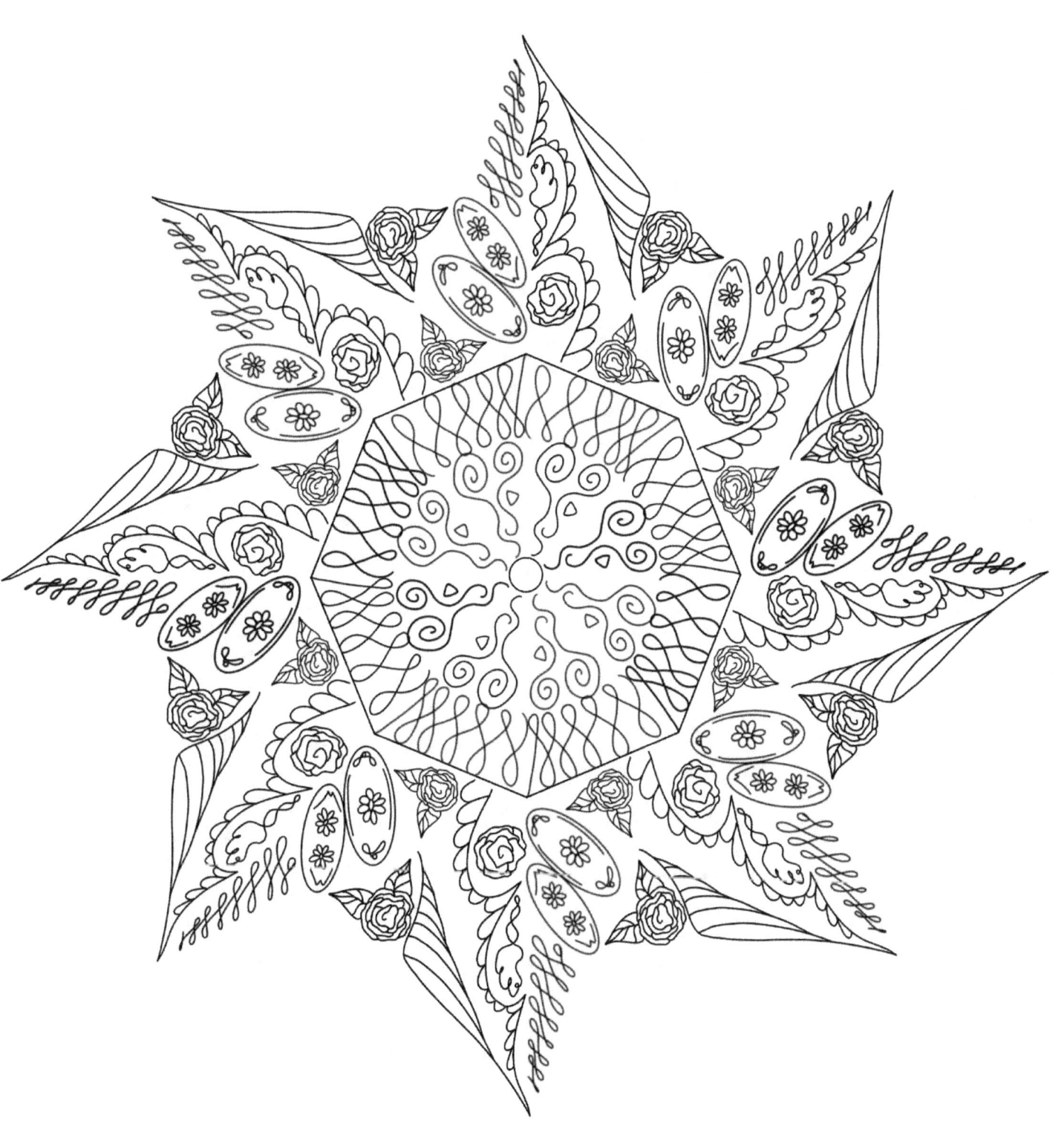

www.ingramcontent.com/pod-product-compliance
Lightning Source LLC
Chambersburg PA
CBHW081501220526
45466CB00008B/2739